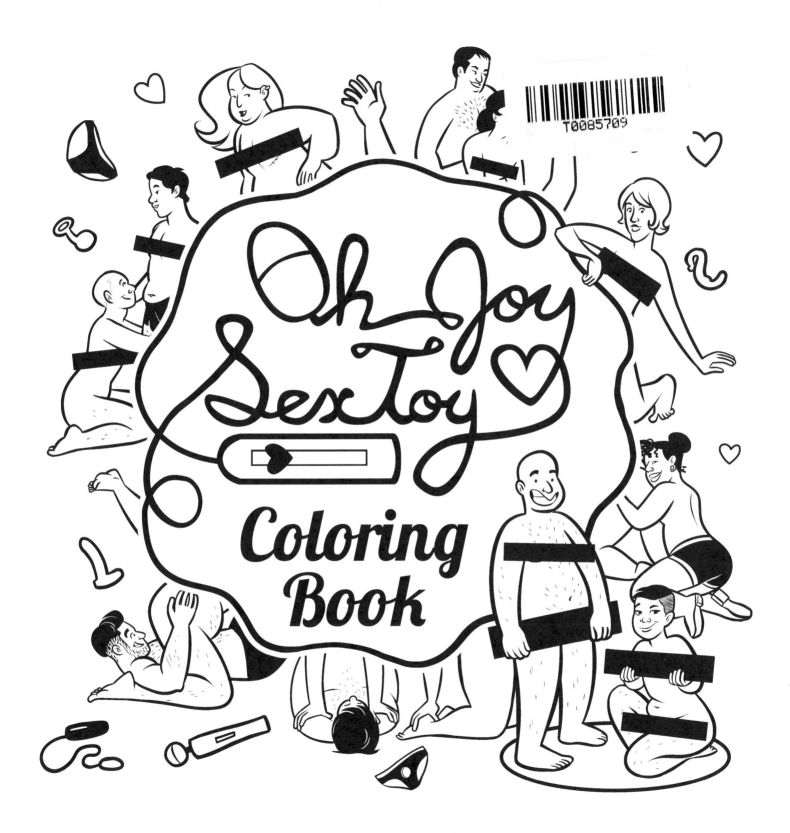

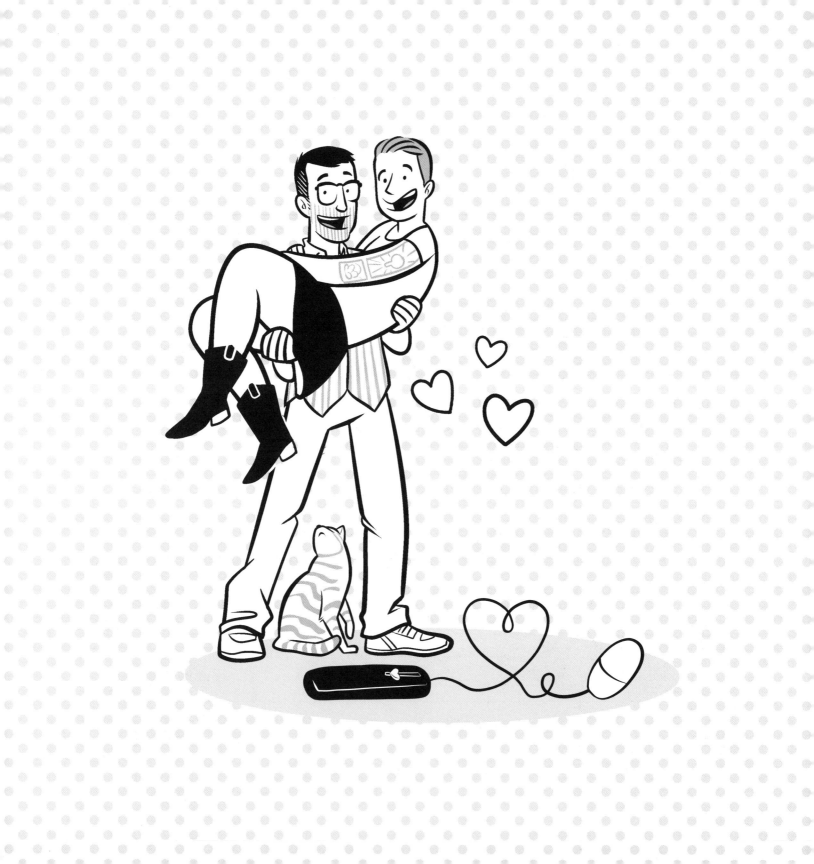

by

Erika Moen
&
Matthew Nolan

designed by
Hilary Thompson

edited by
Ari Yarwood

Published by Erika Moen Comics & Illustration, LLC
Helioscope Studio
333 SW 5th Ave, Suite 500
Portland, OR 97204

Published by Limerence Press
Limerence Press is an imprint of Oni Press, Inc.

Joe Nozemack, publisher
James Lucas Jones, editor in chief
Andrew McIntire, v.p. of marketing & sales
David Dissanayake, sales manager
Rachel Reed, publicity coordinator
Troy Look, director of design & production
Hilary Thompson, graphic designer
Angie Dobson, digital prepress technician
Ari Yarwood, managing editor
Charlie Chu, senior editor
Robin Herrera, editor
Bess Pallares, editorial assistant
Brad Rooks, director of logistics
Jung Lee, logistics associate

 LIMERENCE PRESS

ohjoysextoy.com
twitter.com/erikamoen
facebook.com/erikamoencomics
erikamoen.com

limerencepress.com
twitter.com/limerencepress
limerencepress.tumblr.com

First edition: February 2017
ISBN: 978-1-62010-376-0

 1 2 3 4 5 6 7 8 9 10

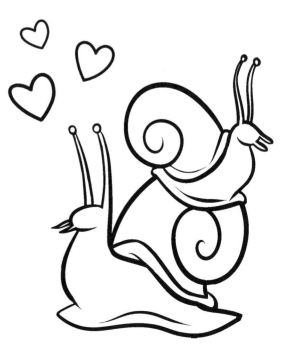

THIS BOOK BELONGS TO:

..

SEARCH AND FIND

See if you can find these items
in the coloring book!

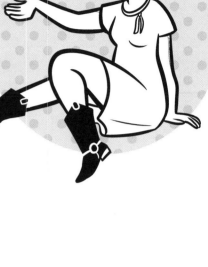

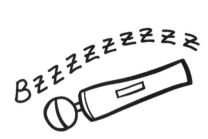

A VIBRATING WAND!

ANAL BEADS!

A BUTT PLUG!

SEX FURNITURE!

MASTURBATION SLEEVE!

UNDERWEAR HARNESS!

A COCK RING!

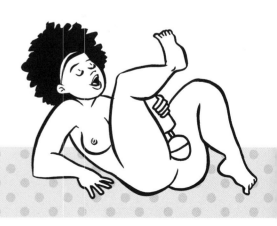

Oh Joy Sex Toy is the critically-acclaimed comic series that thinks sex is pretty rad.

Using humor and research, creators Erika Moen and Matthew Nolan create weekly entertaining and educational comics that illustrate the world of masturbation, sex education, pornography, sex, sex toys, and just generally bein' naked and happy with the aid of their fictional Masturbateers, who joyfully demonstrate all things explicit.

But what happens to all those drawings once they've been debuted in a comic? They sit around, collecting dust! A travesty! And that's where you come in. Help keep the Masturbateers busy by coloring them in with your art supplies!

These randy characters come in all shapes, sizes, sexual orientations, and gender identities. feel free to be as creative with your coloring choices as they are with their sex positions! Aqua for the couple having anal sex, scarlet for that strap-on, orange for the orgy, the sky's the limit!

So what are you waiting for? Grab your favorite color pencils and get busy!

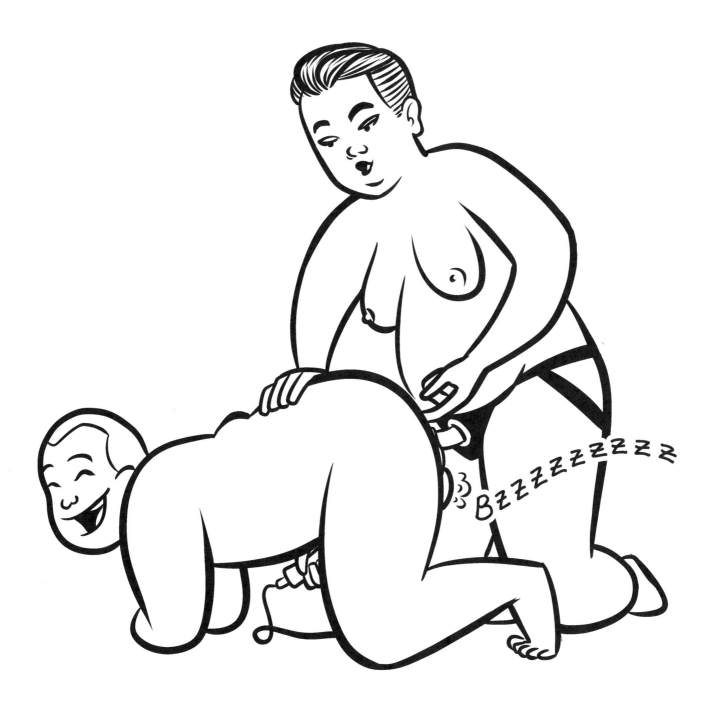

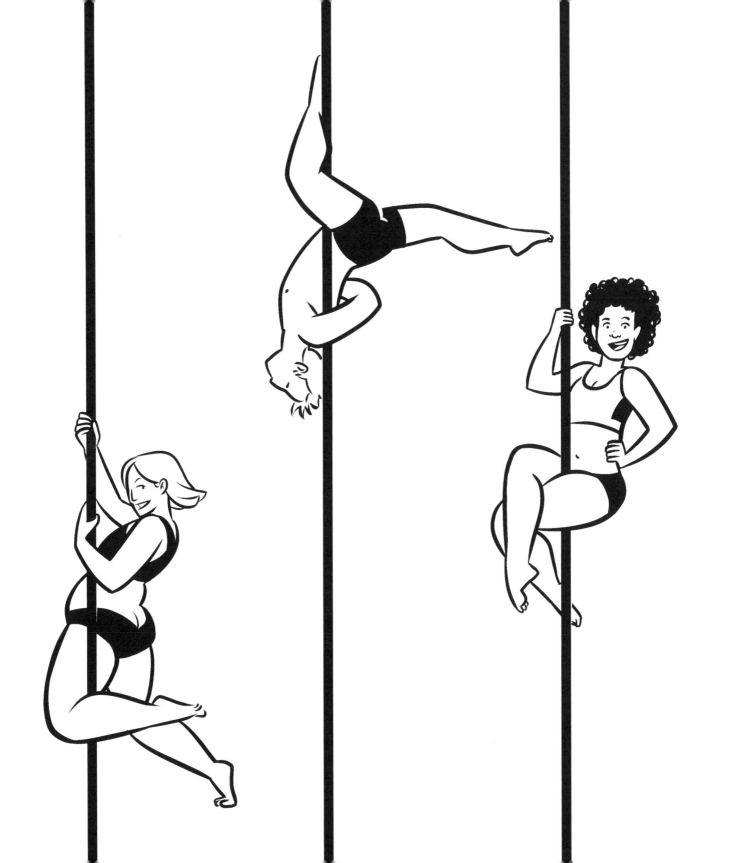

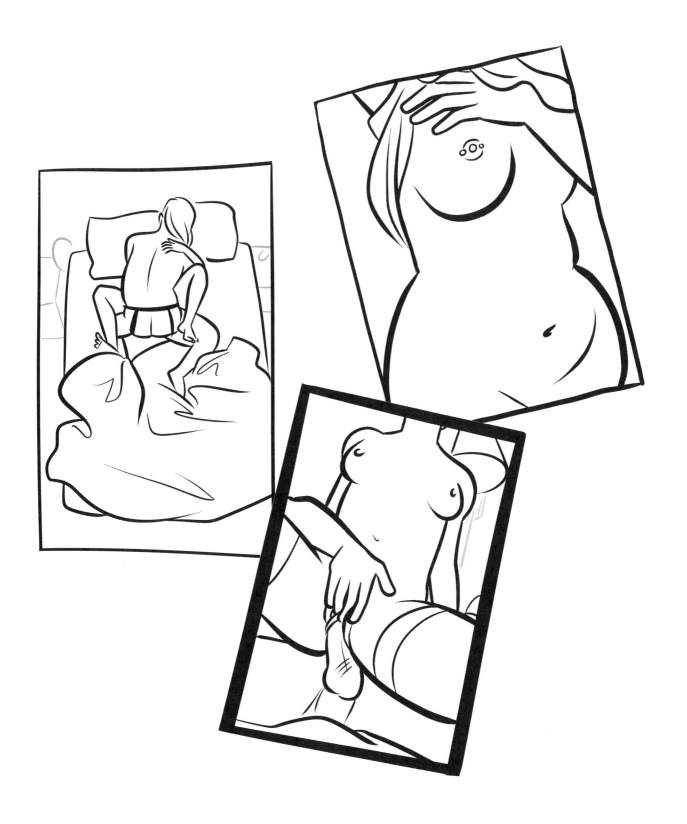

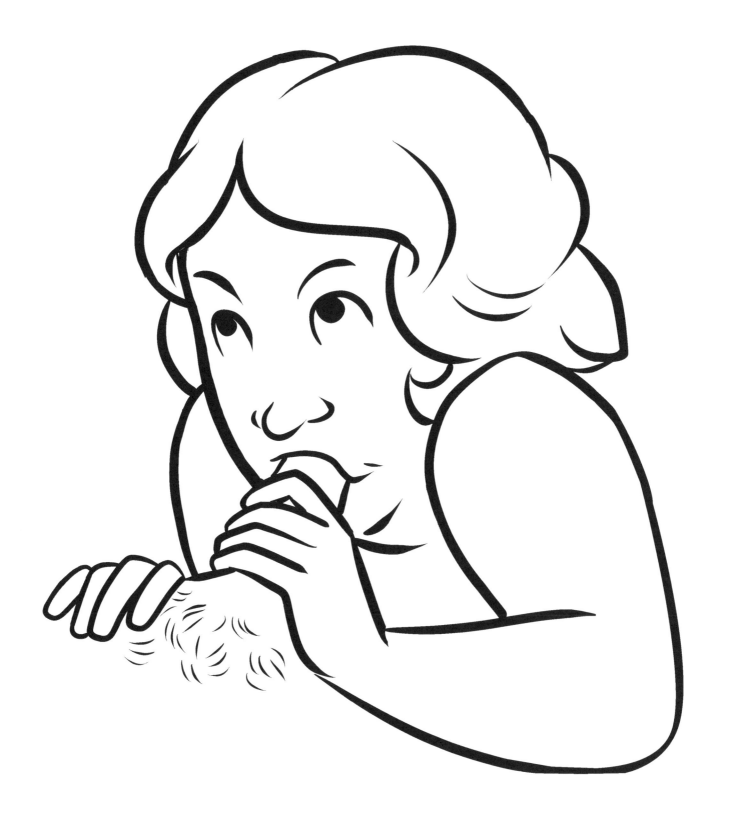

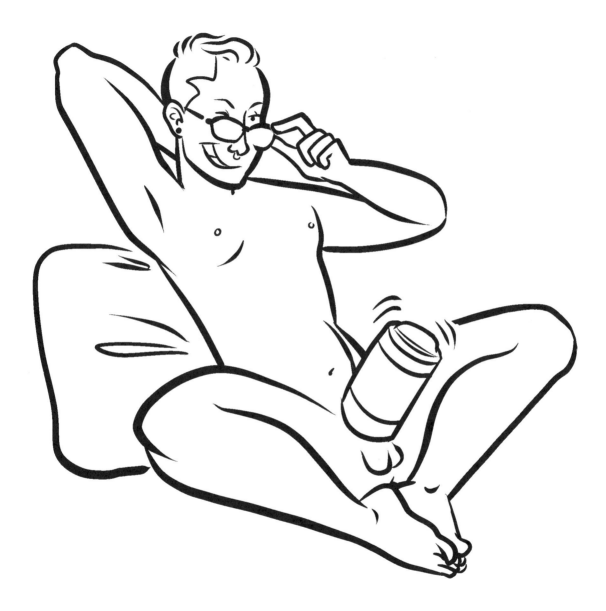

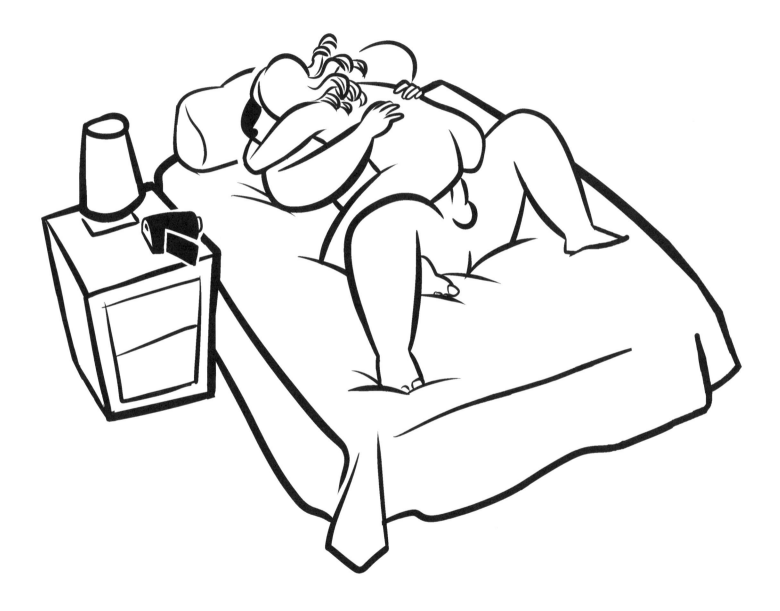

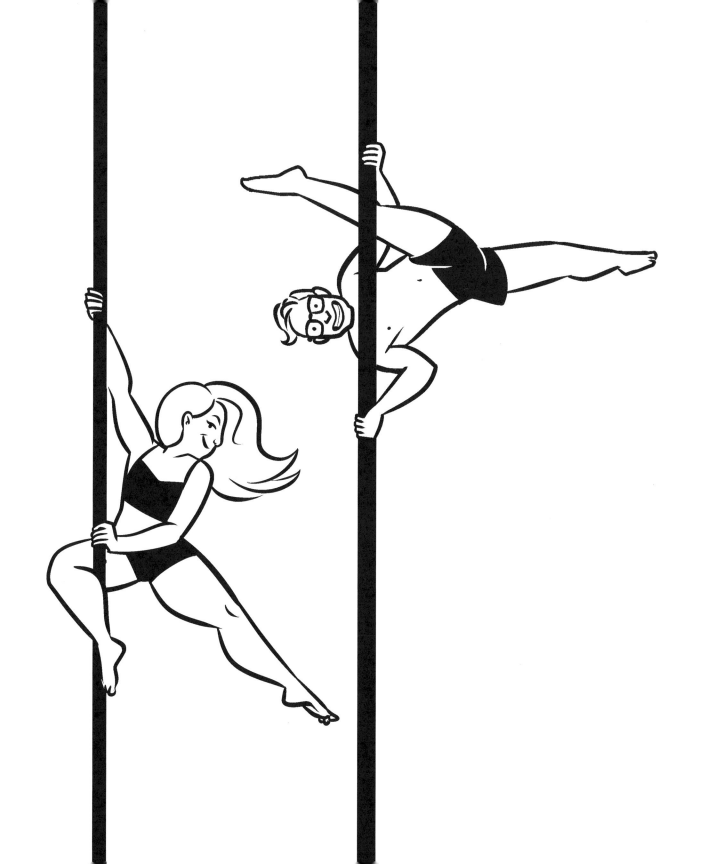

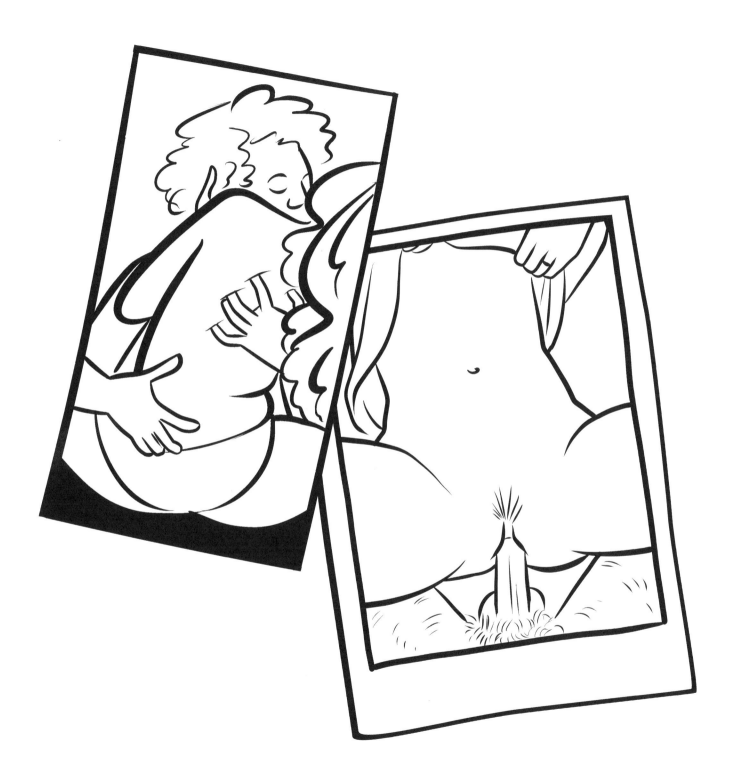

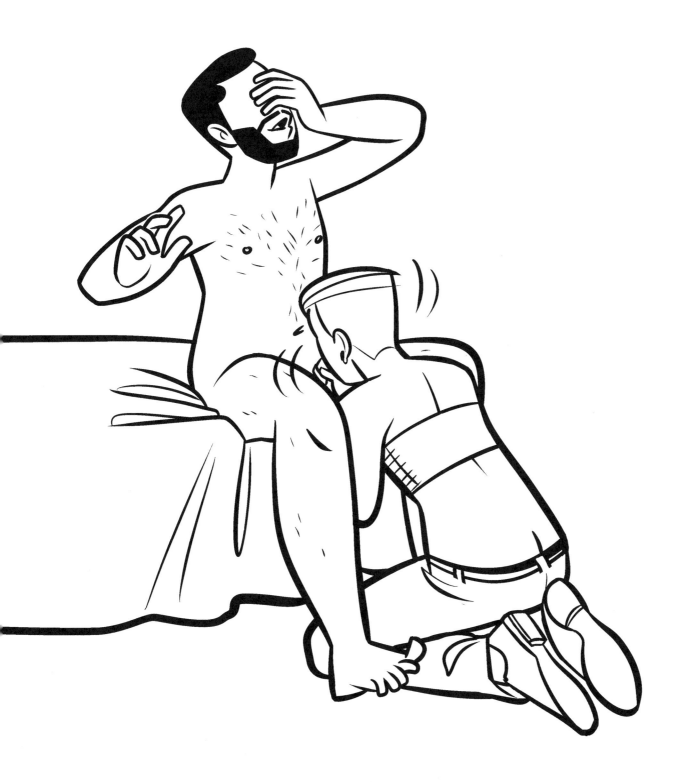

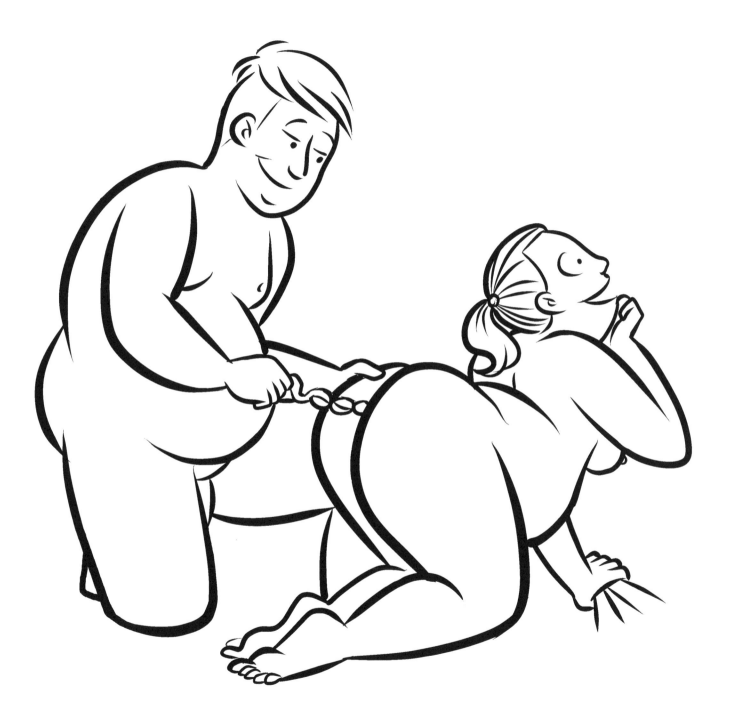

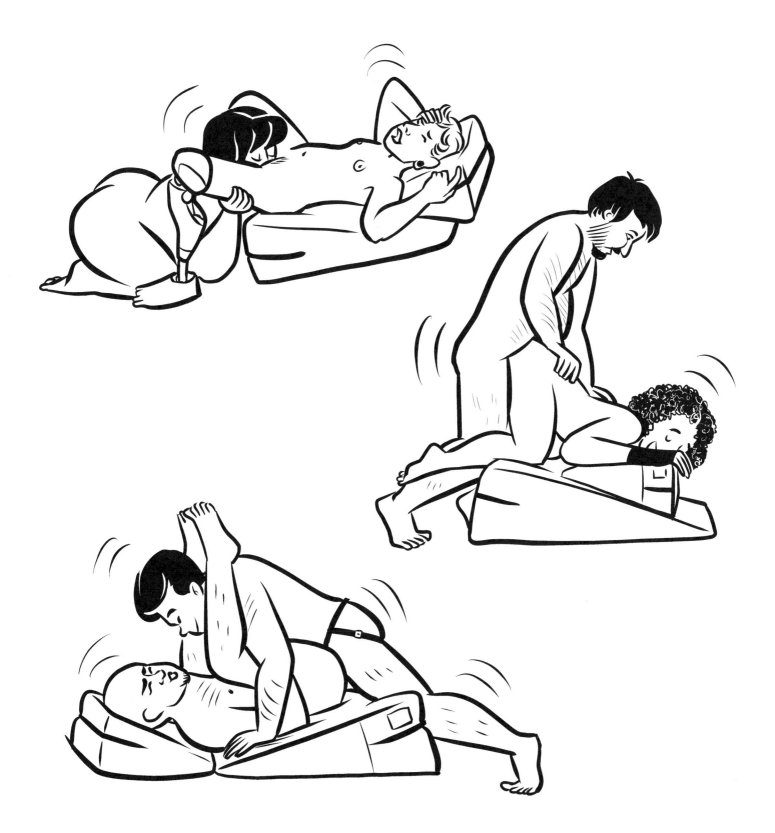

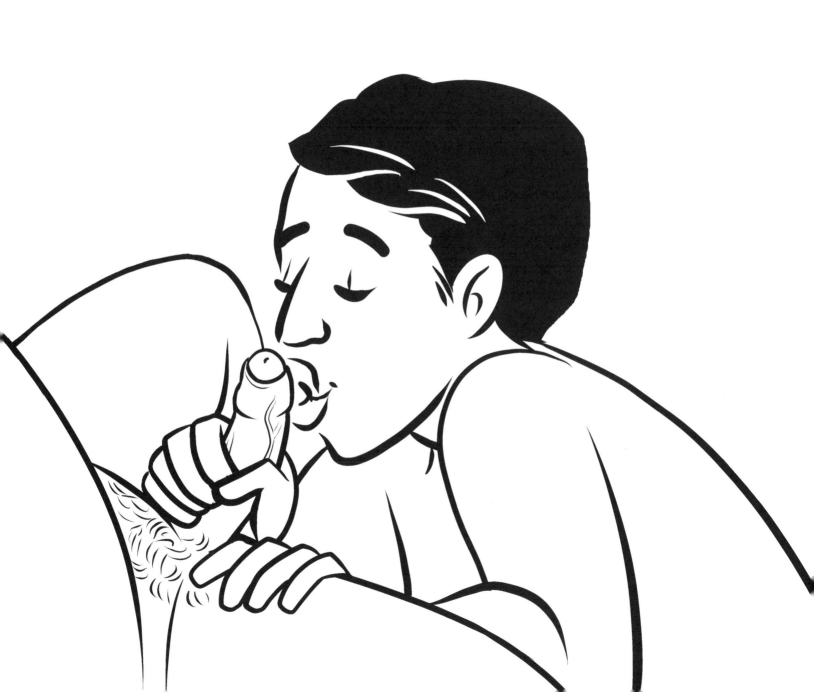

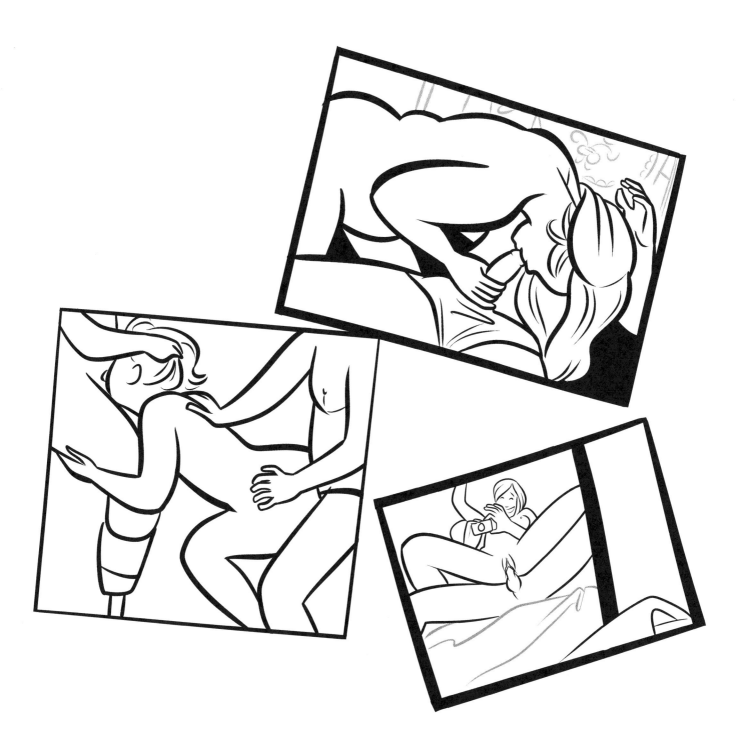

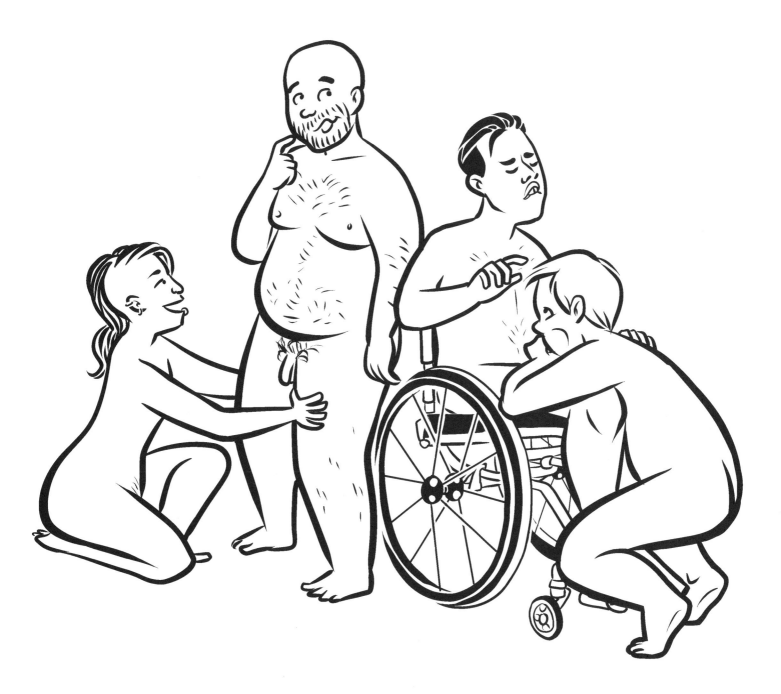

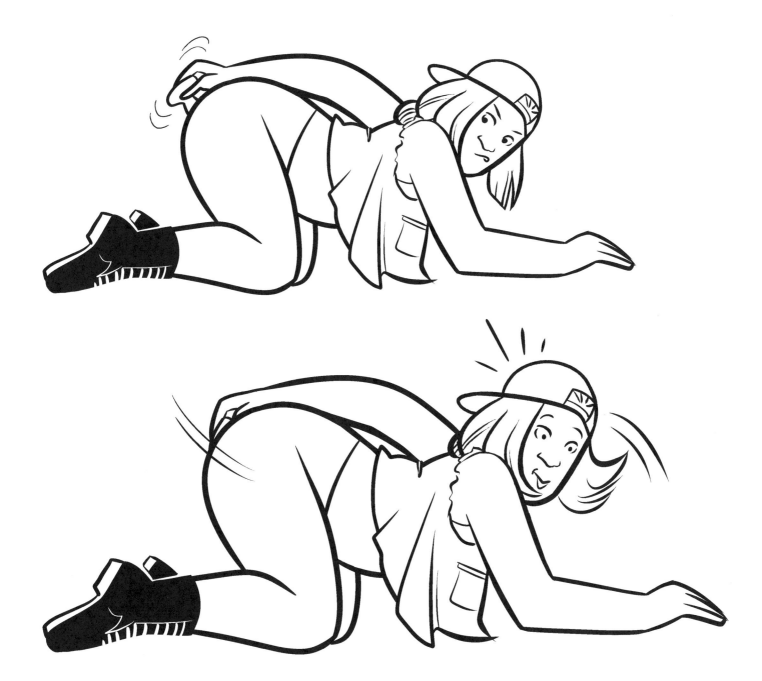

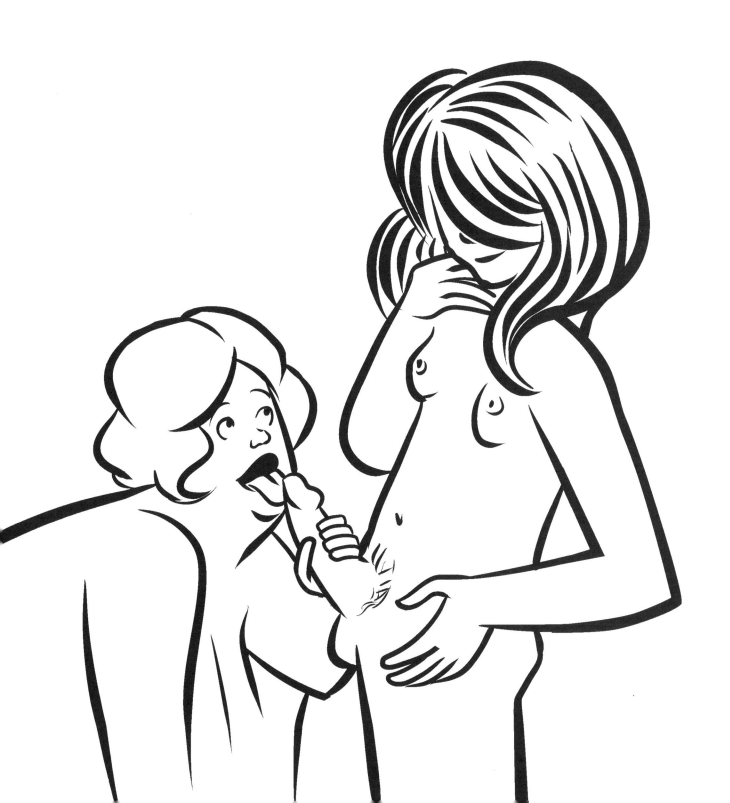

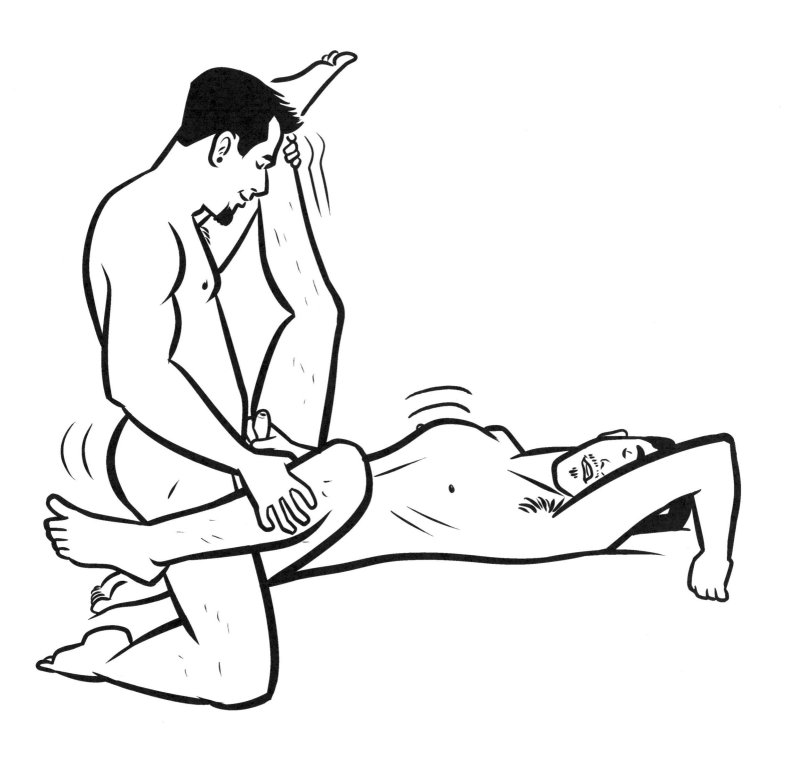

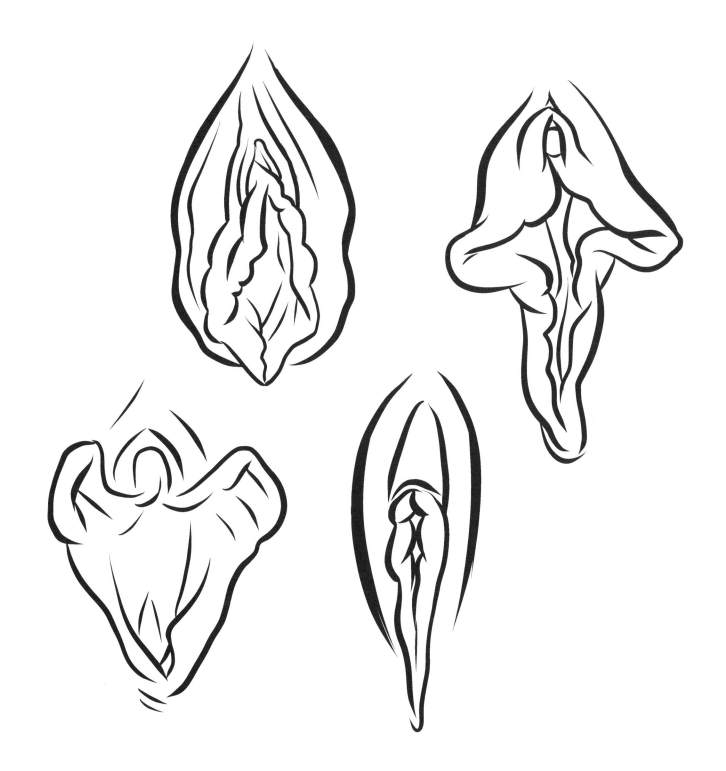

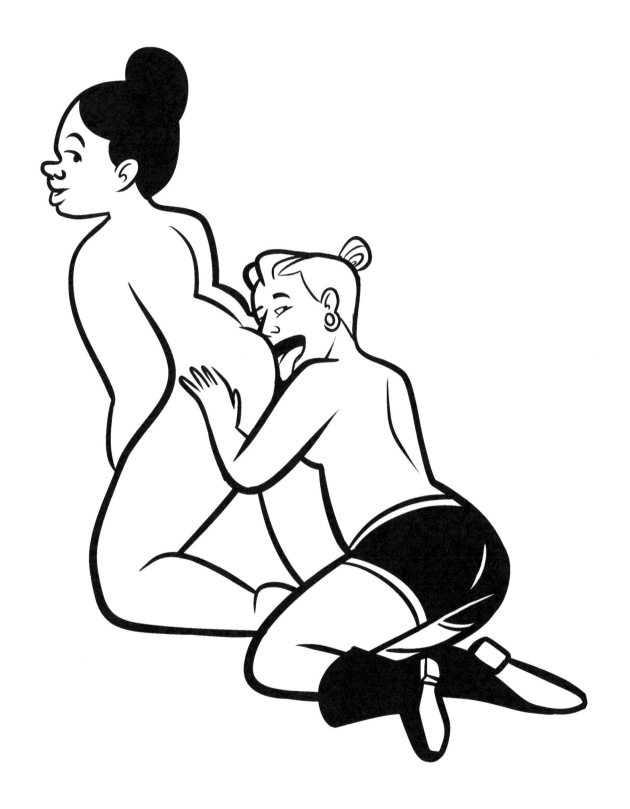

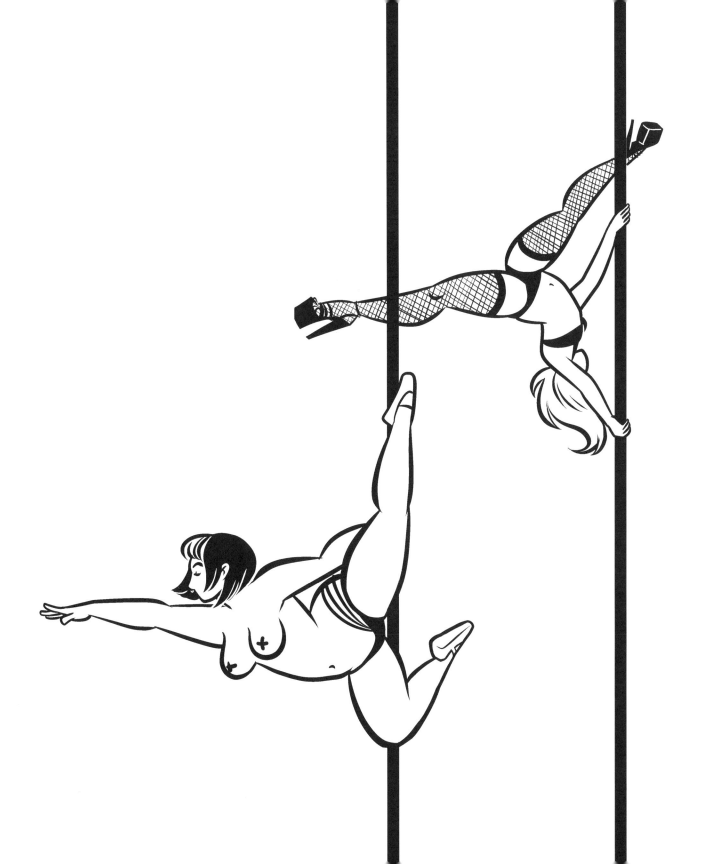

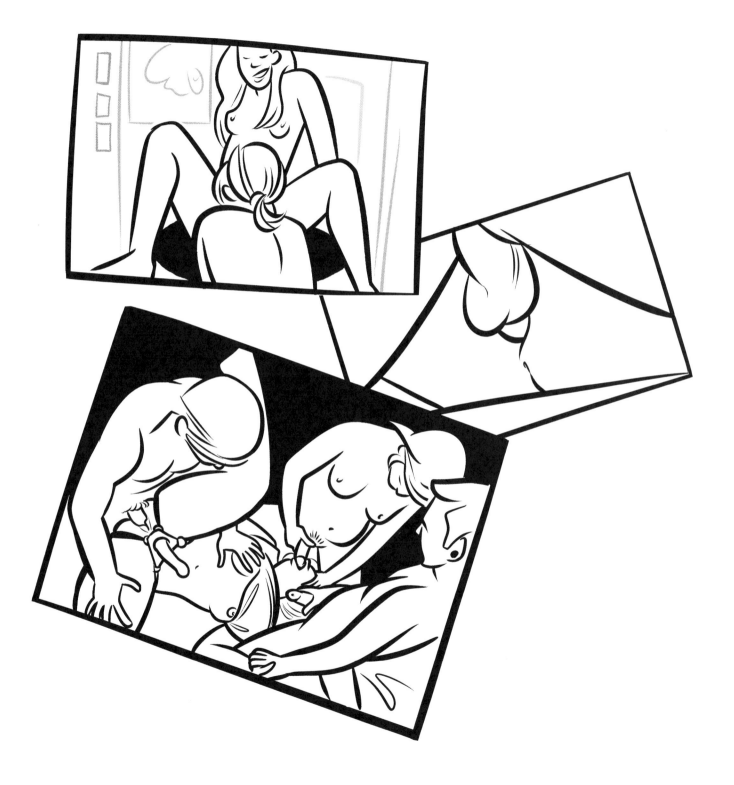

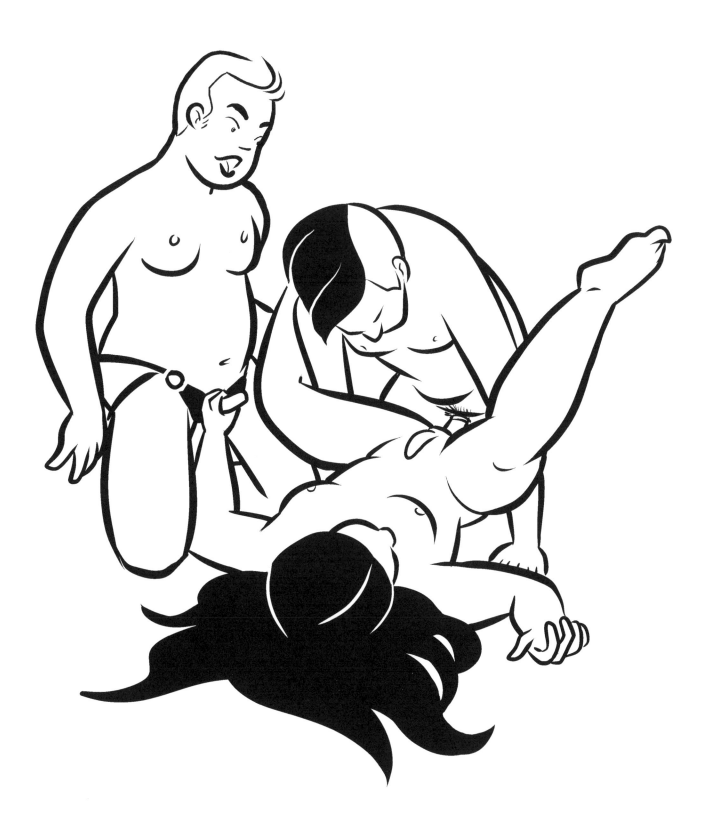

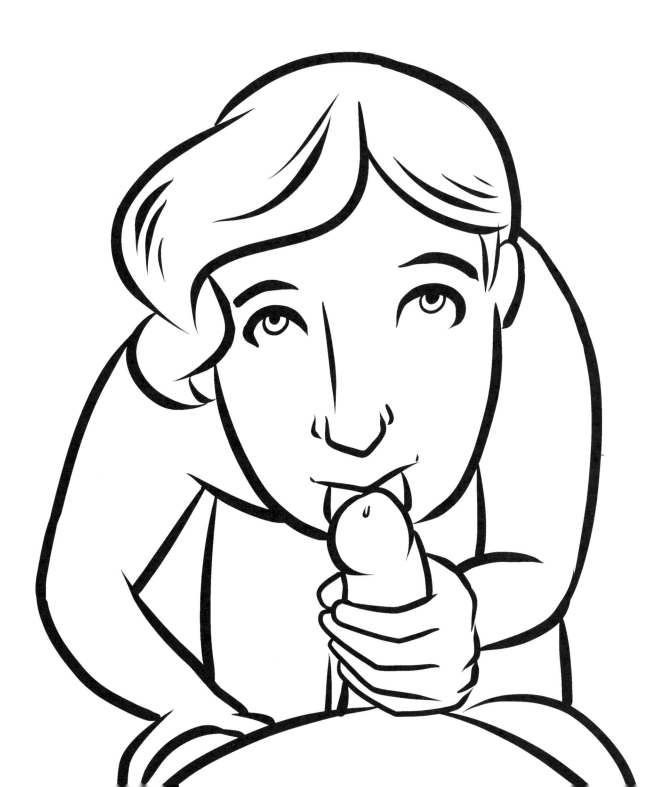

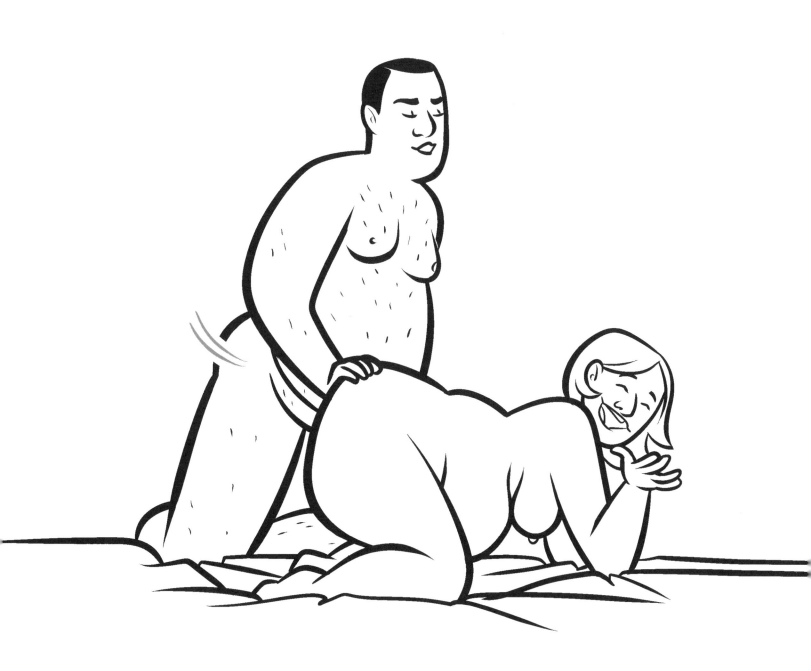

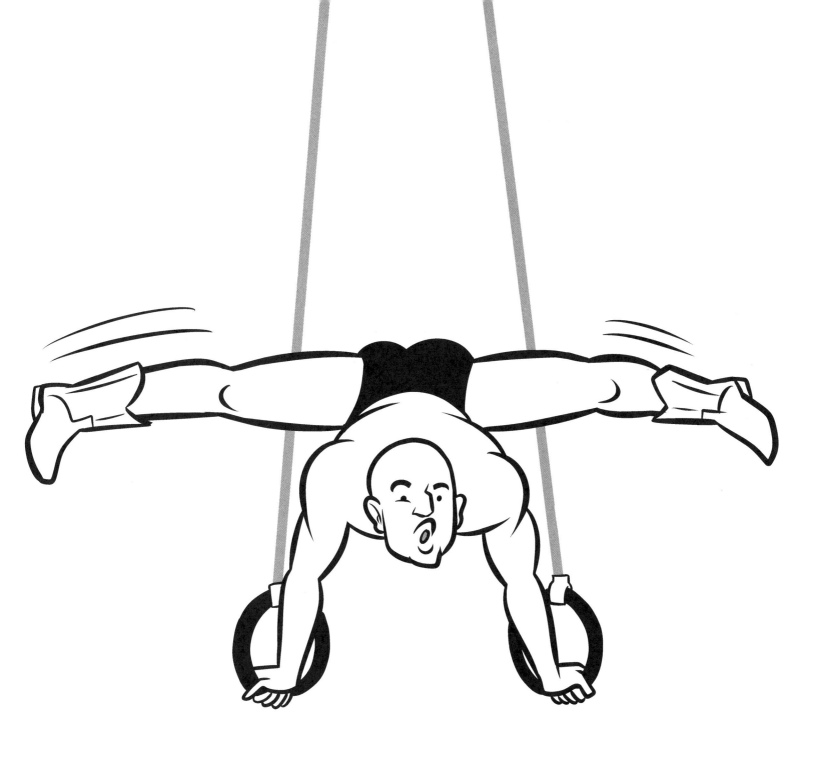

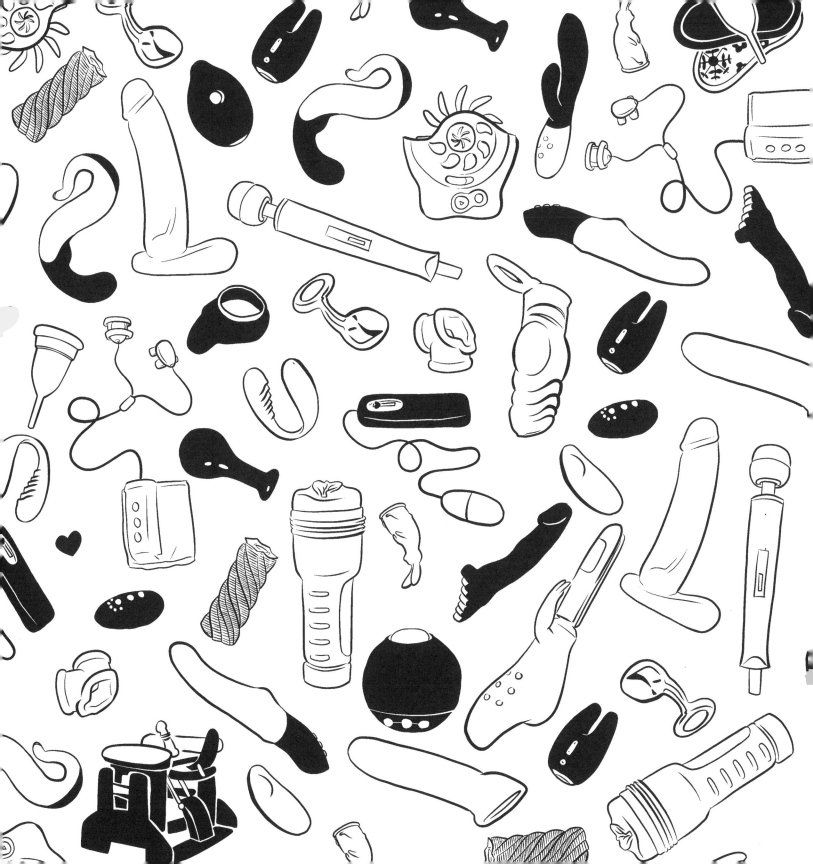

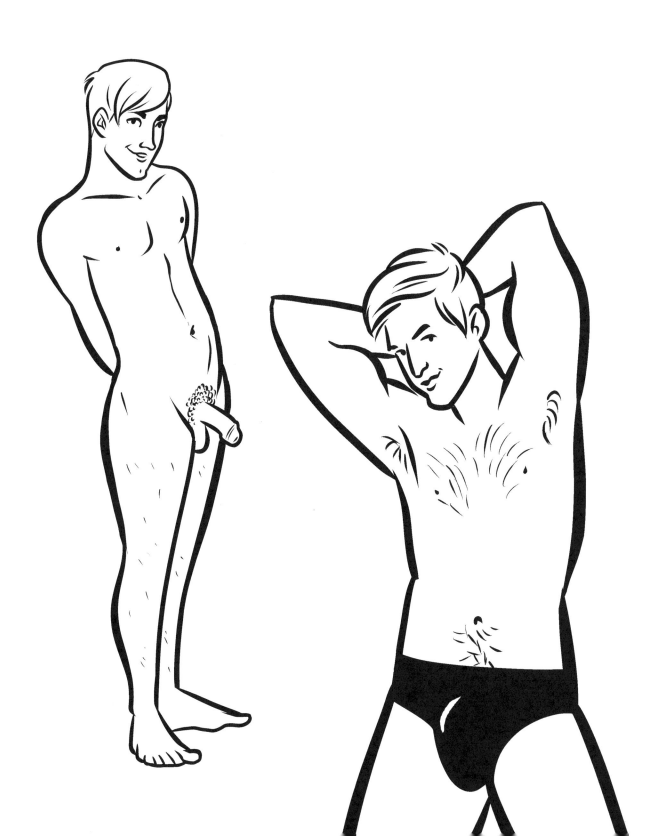

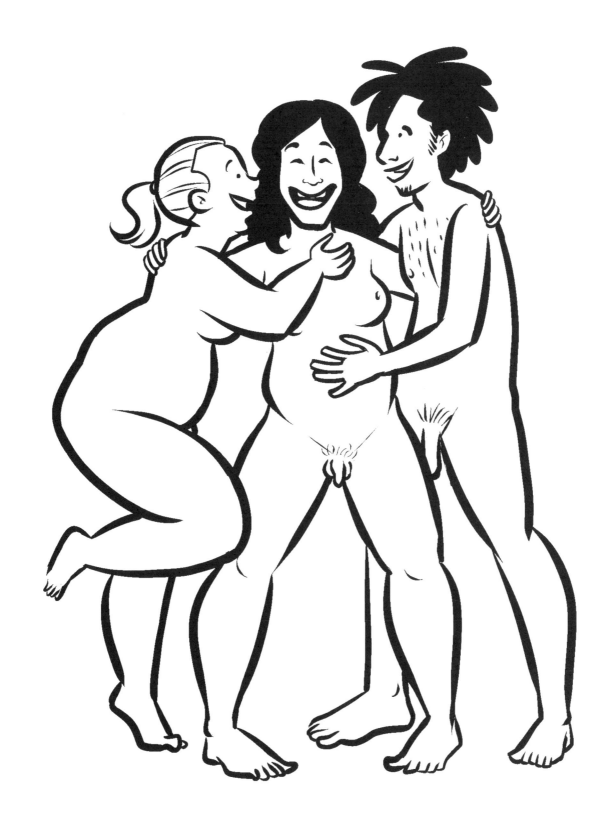

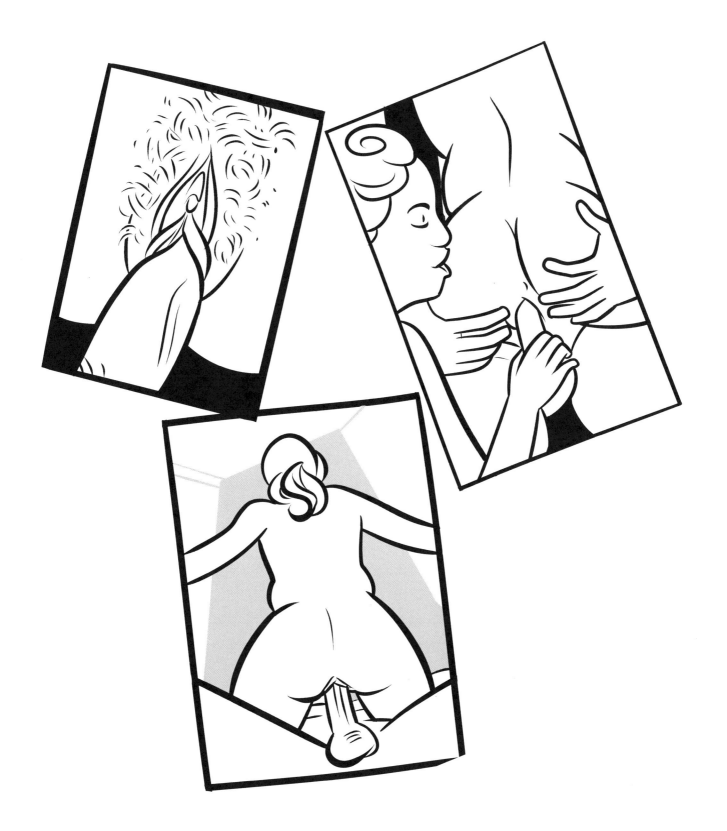

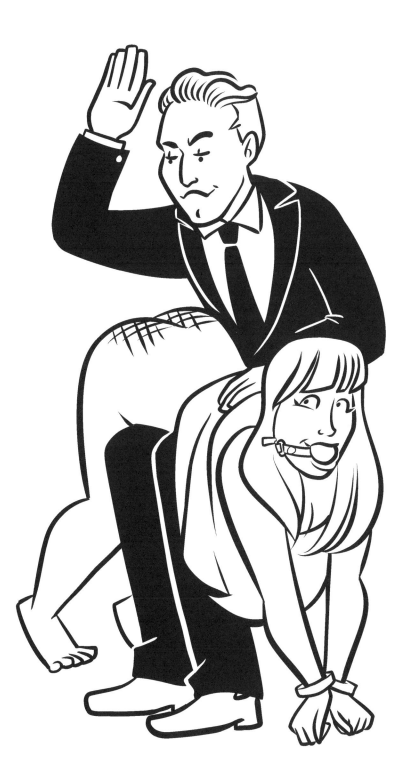

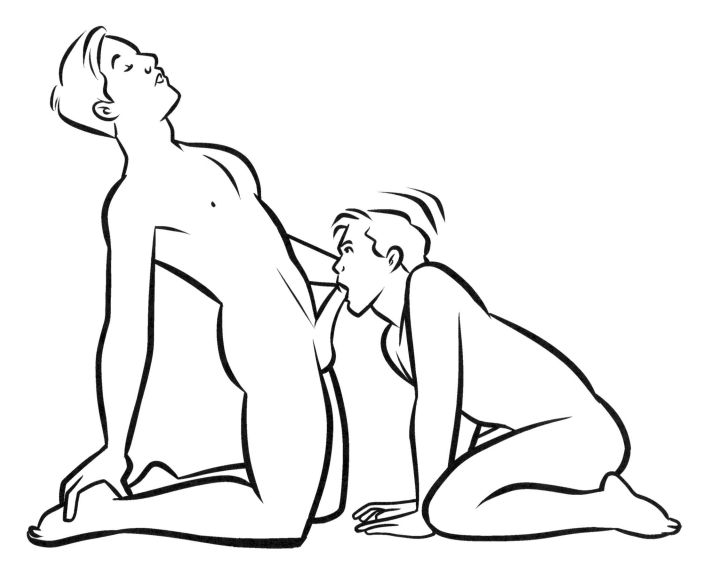

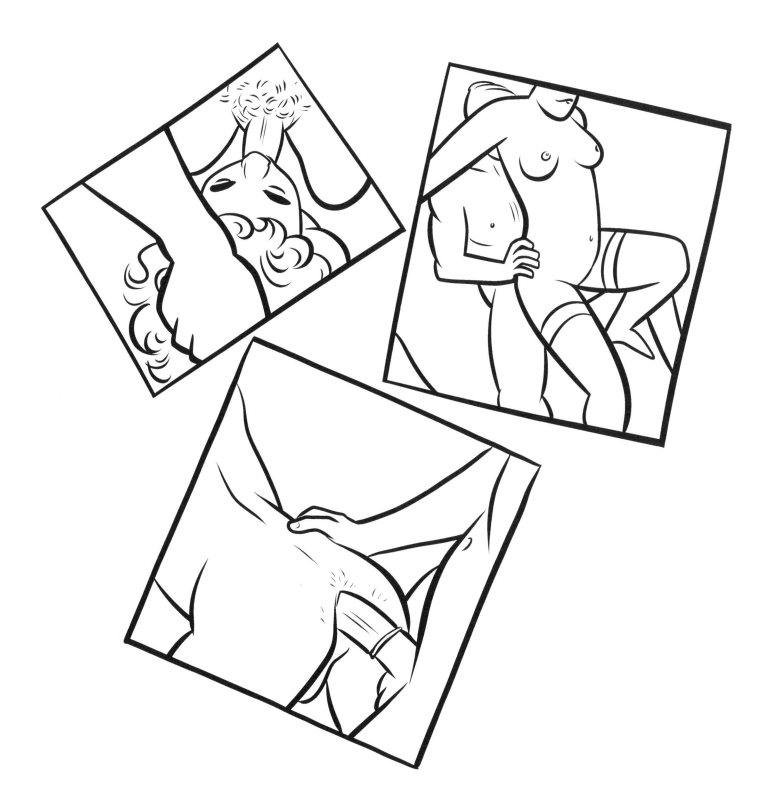

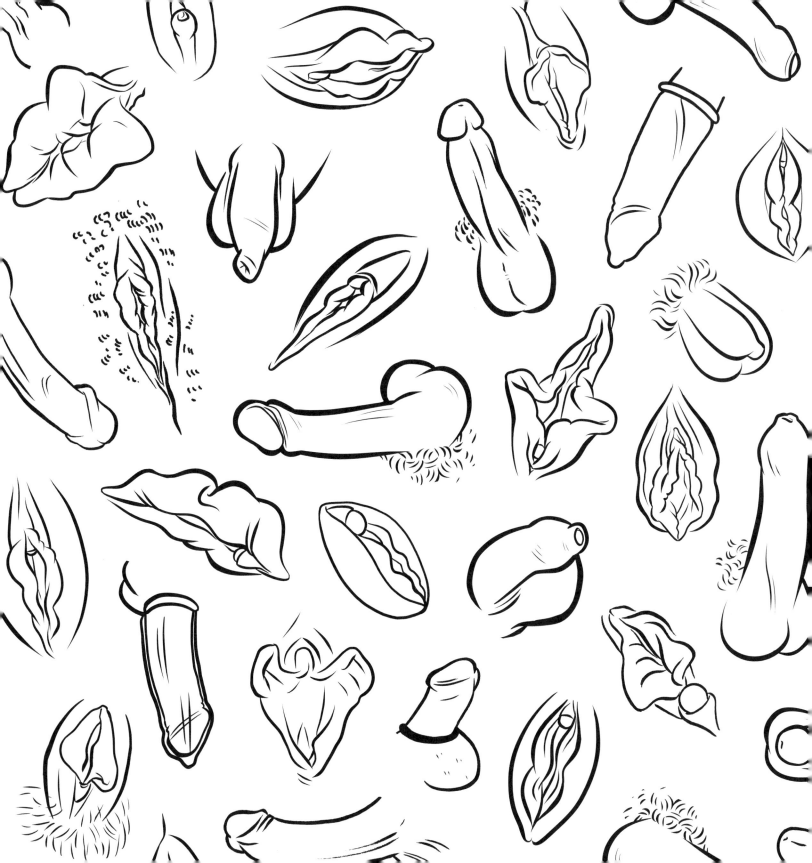

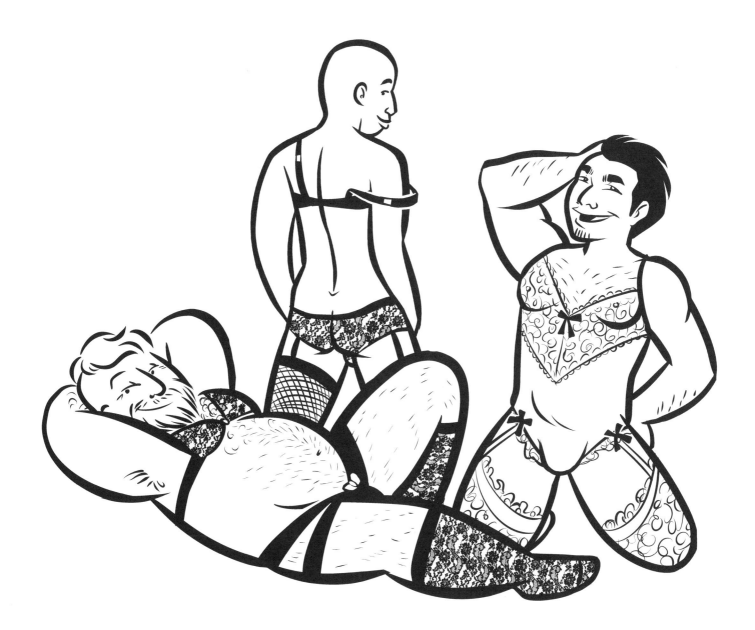

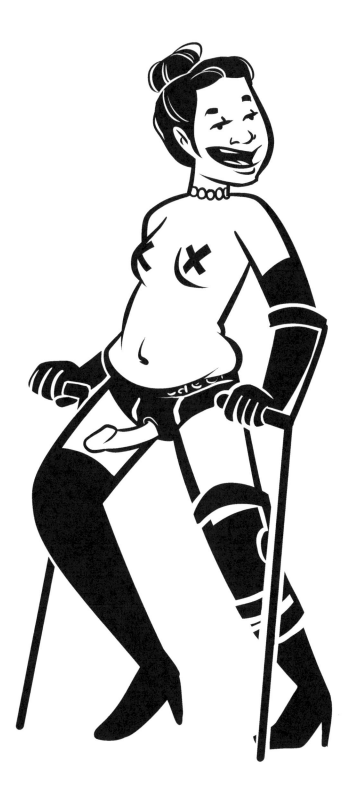

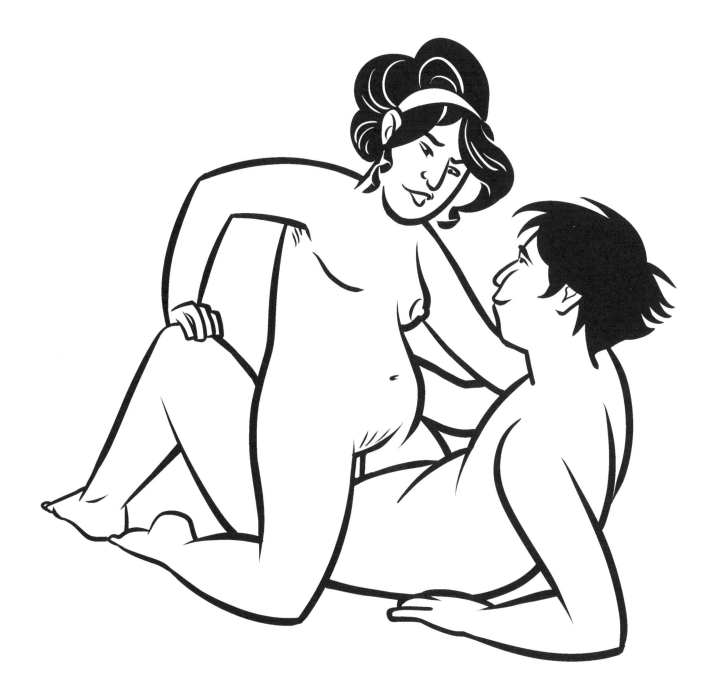

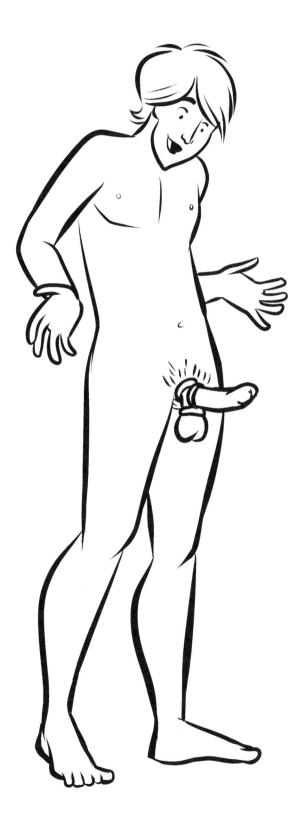

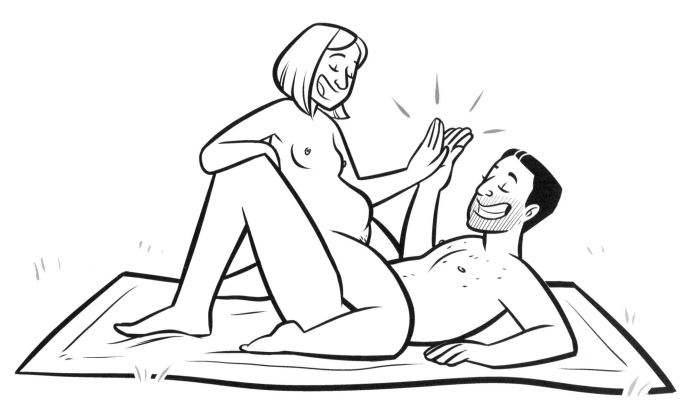

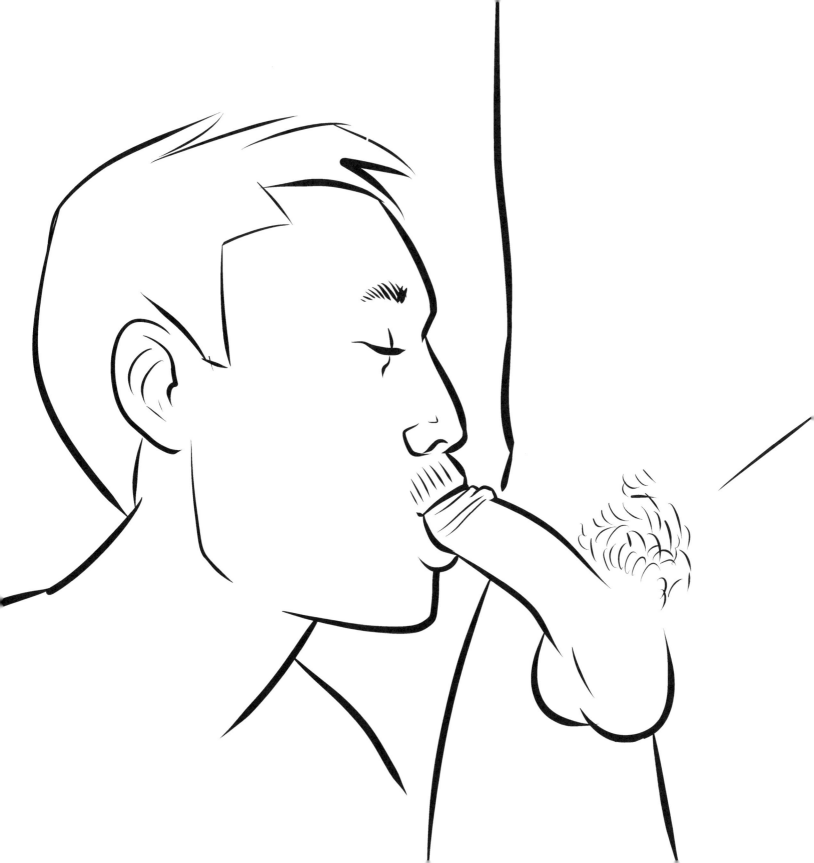

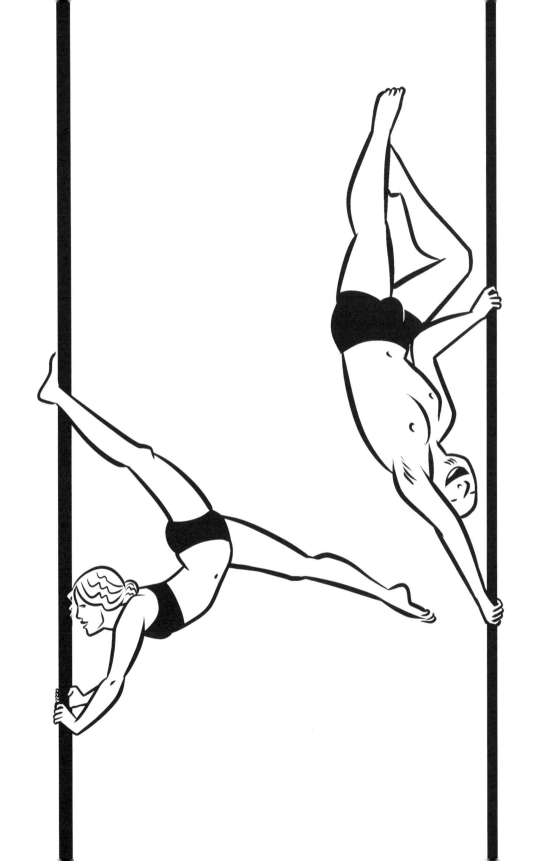

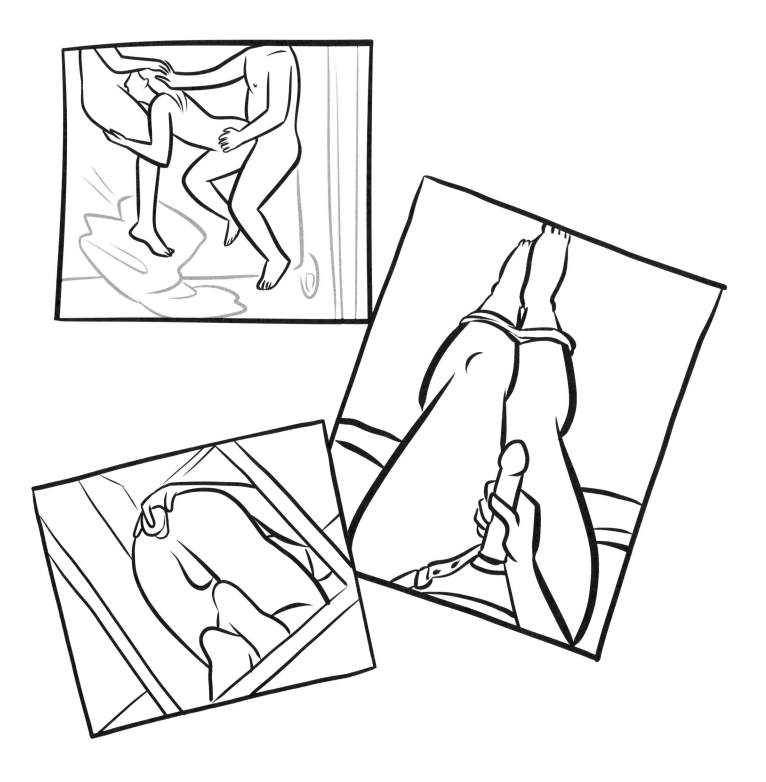

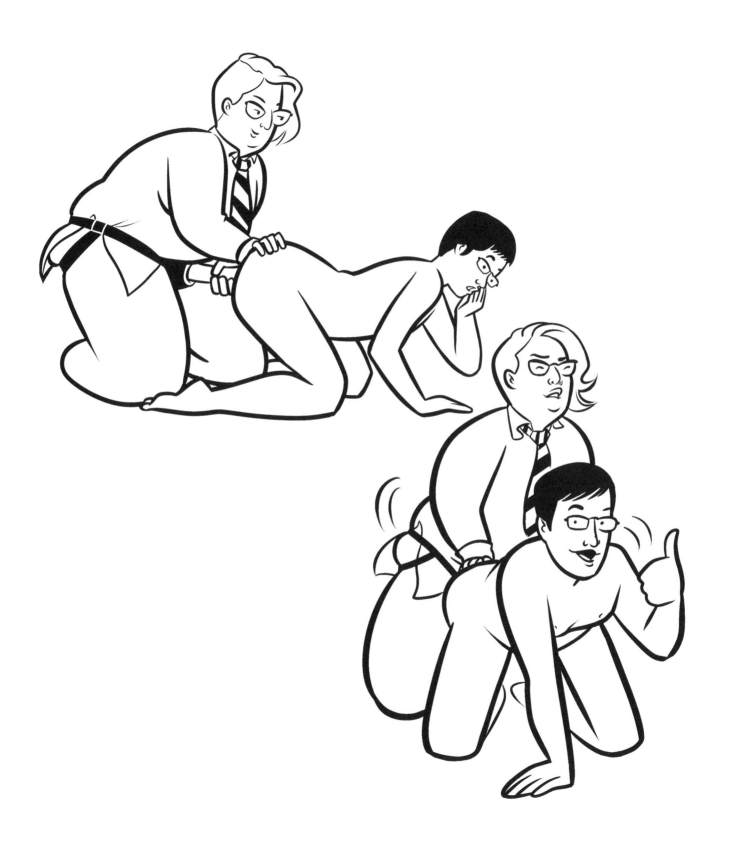

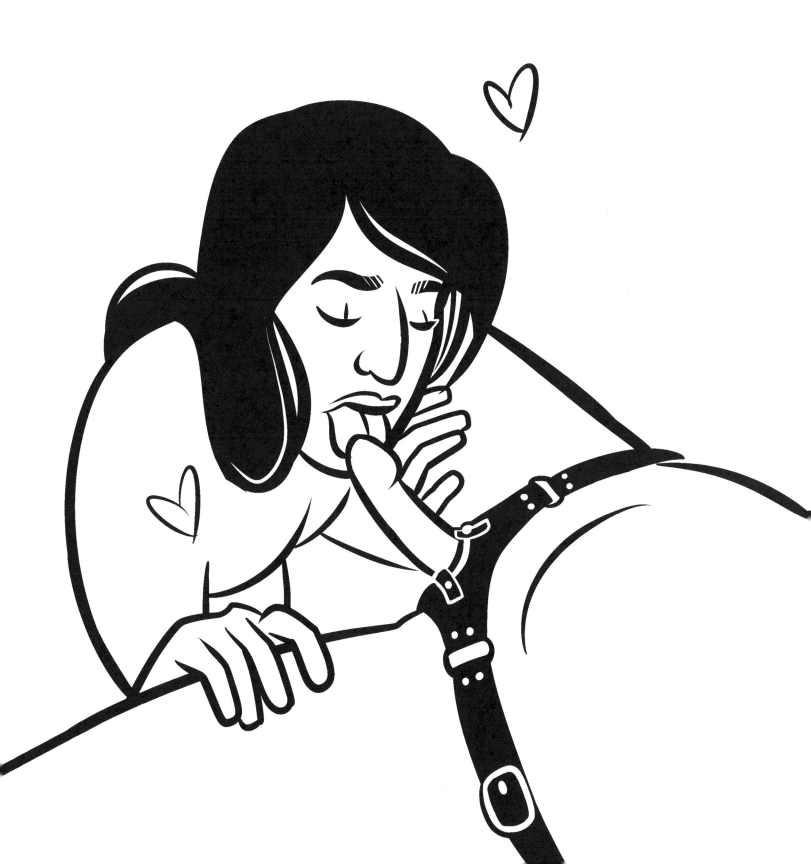

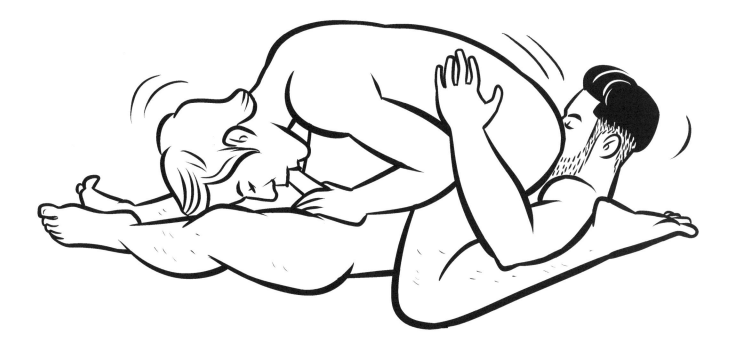

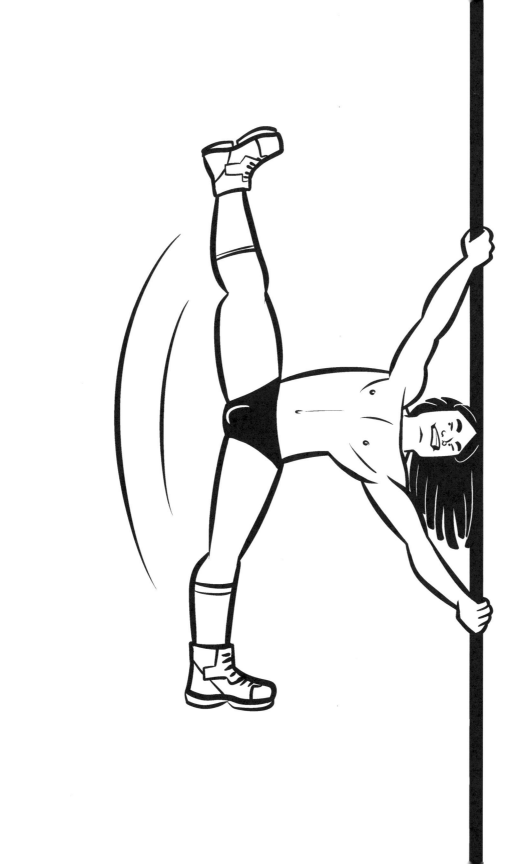

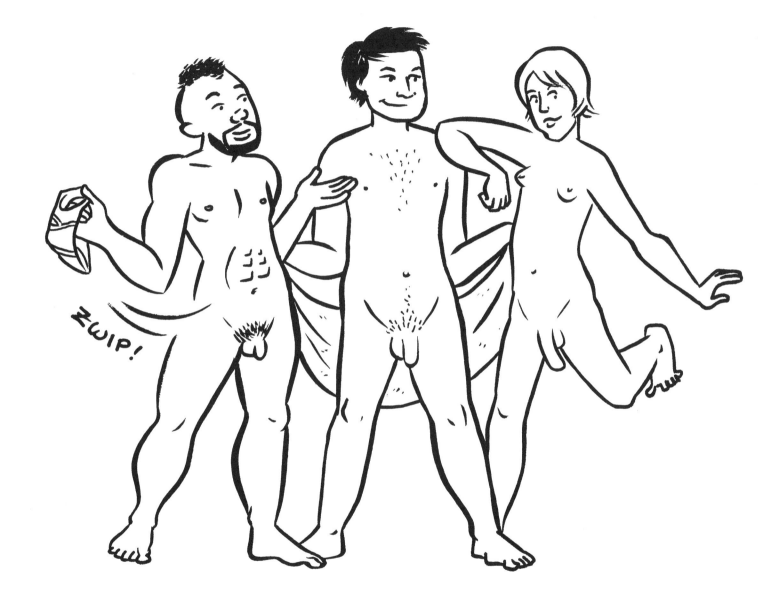

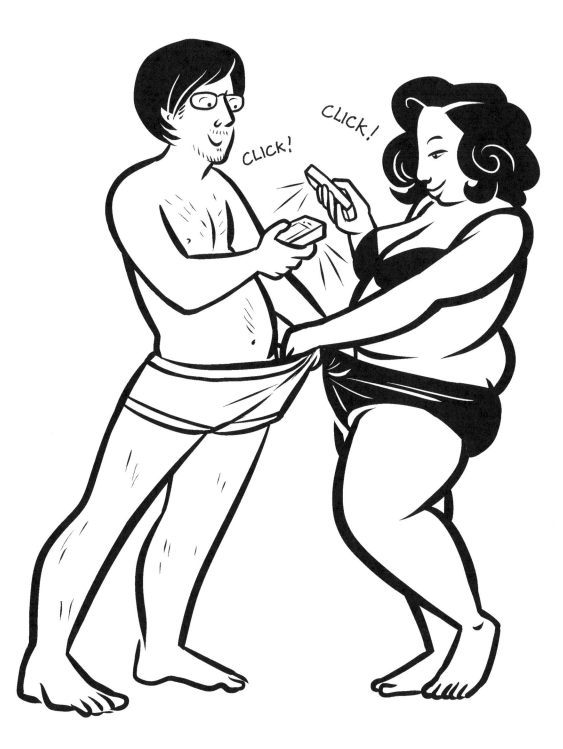

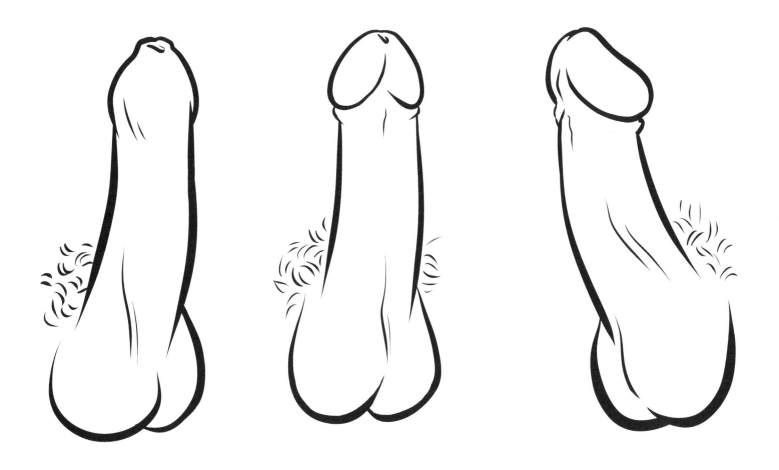

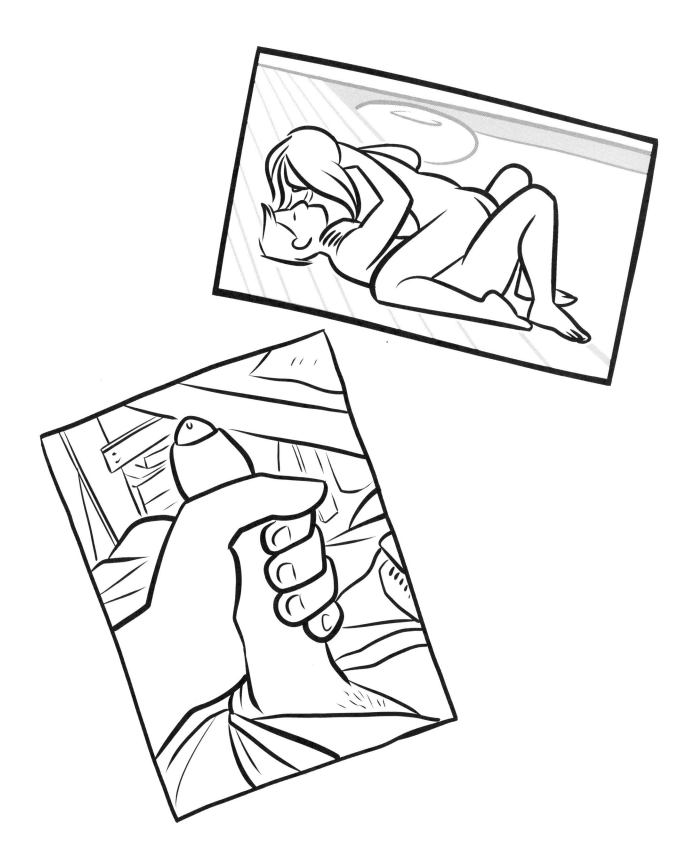

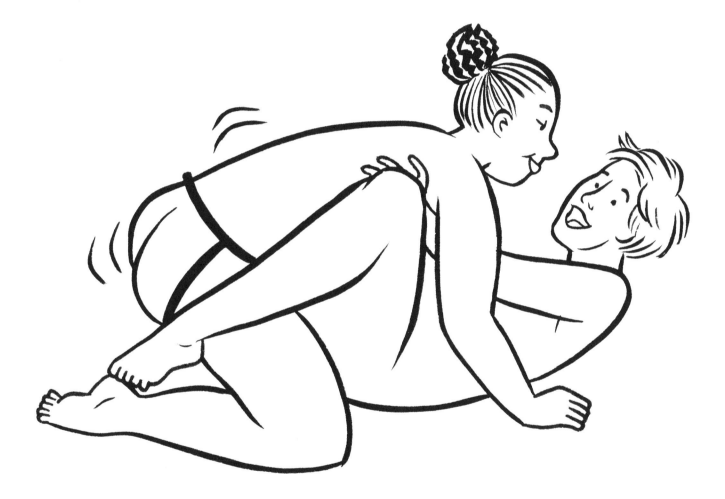

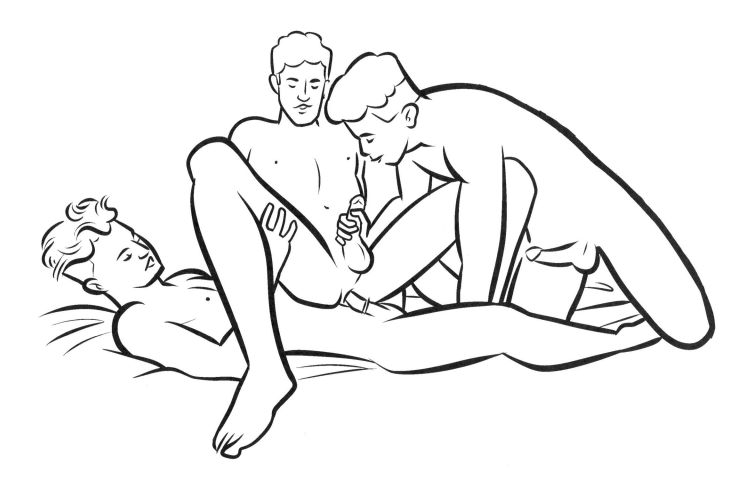

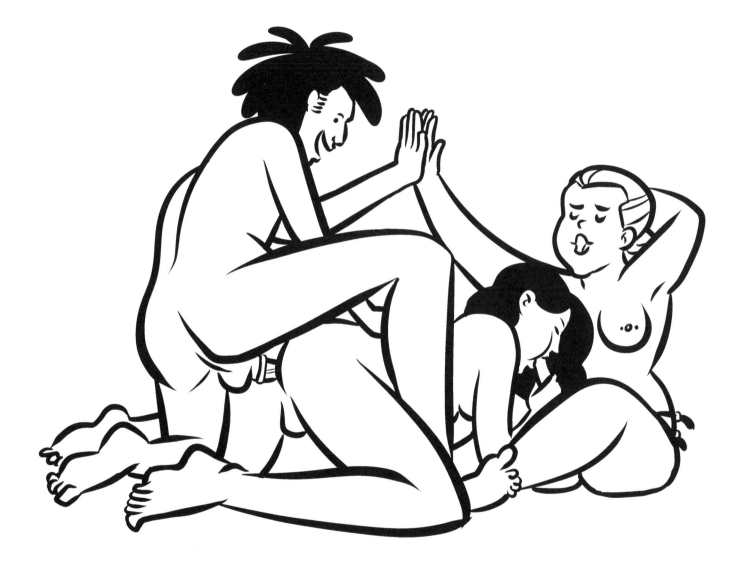

WHERE TO FIND

Did you find all the items?

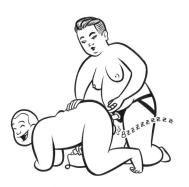

A VIBRATING WAND!

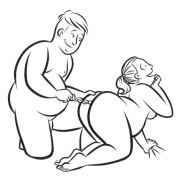

ANAL BEADS!

A BUTT PLUG!

SEX FURNITURE!

MASTURBATION SLEEVE!

UNDERWEAR HARNESS!

A COCK RING!

About the Authors

I'm Erika Moen and this is Matthew Nolan!

We met over a decade ago at a comic convention in England. I can't resist a British accent, so after a few years I tricked him into marrying me. Now we live in Portland, Oregon with our dreadful cat, flapjack, and make *Oh Joy Sex Toy* together.

Oh Joy Sex Toy is a fun and accessible comic that talks about everything relating to sex, including sex toy reviews, sex education, and interviews with folks in the sex industry. We both write the scripts, then I draw it and Matthew does the coloring and extras. I draw at Heliscope, the largest comic book studio in the English-speaking world, and Matthew works from his home office running the *Oh Joy Sex Toy* business. flapjack doesn't really help very much.

We hope you enjoyed this coloring book, and if you're interested in reading the *Oh Joy Sex Toy* comics (which we hope you are!), you can find them at ohjoysextoy.com, or in print volumes from Limerence Press!

Check out *Oh Joy Sex* Toy at OhJoySexToy.com and in these fine volumes!

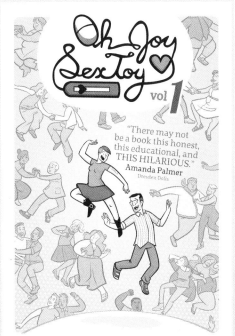

Erika Moen & Matthew Nolan

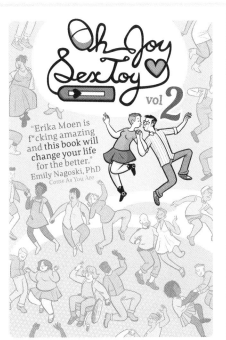

Erika Moen & Matthew Nolan

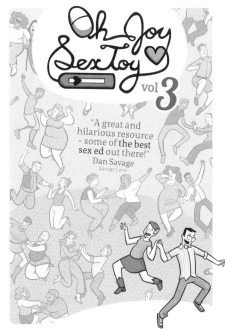

Erika Moen & Matthew Nolan

LIMERENCE